MW01485859

IMAGES
of America

HERMITAGE MUSEUM
AND GARDENS

This postcard of the Hermitage in the 1950s shows the home from across the millstone courtyard. The mechanical building on the left is connected to the rest of the structure via a covered breezeway that was added to the home in the late 1930s. (Courtesy of Hermitage Museum and Gardens.)

ON THE COVER: The Hermitage Museum began as a retreat from the industrial center of Norfolk. By the time this photograph was taken in the early 1930s, the home had evolved into a sprawling estate on the banks of the Lafayette River. (Courtesy of Hermitage Museum and Gardens.)

IMAGES
of America

HERMITAGE MUSEUM AND GARDENS

Colin Brady

ARCADIA
PUBLISHING

Copyright © 2013 by Colin Brady
ISBN 978-1-4671-2061-6

Published by Arcadia Publishing
Charleston, South Carolina

Printed in the United States of America

Library of Congress Control Number: 2013938498

For all general information, please contact Arcadia Publishing:
Telephone 843-853-2070
Fax 843-853-0044
E-mail sales@arcadiapublishing.com
For customer service and orders:
Toll-Free 1-888-313-2665

Visit us on the Internet at www.arcadiapublishing.com

To my parents; thank you for supporting me through all of my endeavors

CONTENTS

ACKNOWLEDGMENTS

There would not be a Hermitage Museum and Gardens without the vision of William and Florence Sloane. Along with their sons William Jr. and E.K., they made contributions to the city of Norfolk that have made this southeastern Virginia town a far better place for the arts.

I would like to give a big thank-you to the Hermitage board of trustees for supporting this project, as well as the executive committee, including Robert E. Garris Jr., Christine Neikirk, Olin Walden, and Nancy Nusbaum, for allowing me to pursue this work. In addition, I must thank Eleanor Lewis, James Valone, Nancy Branch, Mark Lewis, Peggy Haile-McPhillips, Sheila Jamison-Schwartz, and Jennifer Moore for being an amazing collections committee that believes there is something truly special about this museum and its history.

To the staff, past and present, thank you for all that you have done to make this book become a reality. I could not ask for better colleagues and friends. Melanie Mathewes, Tom Allan, Yolima Carr, Melissa Ball, Truly Mathews, Matt Serino, Megan Frost, Alanna Kibiloski, Lil Acosta, Allie Lane, and Pat Merica, you are all dear to my heart. To all of the volunteers and interns who transcribed and scanned images and documents, I say thank you as well.

I must extend my most sincere gratitude to Kristin Law and Lauren Northup, whose long hours and extensive work as curators at the Hermitage have given me the foundation for this book. Without you, this could not exist.

I am also very grateful to Lissie Cain, Julia Simpson, and Arcadia Publishing for finding the history of this institution as important as we, the Hermitage family, feel it is.

The source material for this book, both the writing and the images, has come from the personal archives of the Hermitage Museum and Gardens. Through the use of personal correspondences, receipts, journals, and business letters written by or received by the Sloane family, I have been able to create the text for this book.

INTRODUCTION

In 1893, newlyweds William and Florence Sloane traveled from New York to Norfolk, Virginia. William had arrived several years earlier with his maternal uncle Foster Black. At the age of 19, the young college graduate and his uncle began the first of three knitting mills in Berkley, across the Elizabeth River from Norfolk. William acquired the business in 1905, after his uncle passed away, and renamed it William Sloane & Co.

The young couple built their first home, with the assistance of English master wood-carver Charles J. Woodsend, on the corner of Chesapeake Avenue and Ohio Street in South Norfolk. For the better part of a decade, the family lived in this neighborhood, which was in proximity to the mills operated by William. In 1907, the Sloanes acquired several acres of farmland on Tanners Creek in Norfolk County, with plans to build a summer retreat. A year later, in January 1908, they and Woodsend began work on the Hermitage, a five-room summer cottage. The original five rooms were typical of a Northern estate of the era, with heart-white cypress shingles and trim, brick, and half-timbering around the home. The foundation was irregular, with a second story above the main room (now the great hall), and a large tiled porch across the width of the hall. At the front of the house, a formal porte cochere led guests to the front entrance.

The estate was alive with sheep, horses, cows, and chickens, which were housed in the stables that were constructed in 1910 at the front of the property. By this time, the Sloanes had two young sons, William Jr. and Edwin "E.K.," and they began preparations to expand the Hermitage so they could live there year-round. Oak paneling was added, hand-plastered walls were installed, and the formal dining room and master bedroom were added in 1912. In 1916, the Sloanes contracted W. and J. Sloane & Company of New York City to build an expansion to the eastern part of the home. A library and master suite with full his and hers bathrooms, a sleeping porch, and a formal dressing room for Florence Sloane were added. In addition to the suite, a morning room with linen-fold carving in the paneling was attached to the home. On the exterior, Karl von Rydingsvard attached hand-carved bargeboards on the eaves.

With the onset of World War I in 1914, the Sloanes' mills saw an increase in productivity. The financial gains from this era allowed the Sloanes to respond to the community with increased acts of altruism. Their new wealth also afforded the family the means to expand their home into a sprawling estate. It was during this time of home expansion that the grounds were opened as a retreat for the military. The Sloanes, in partnership with the YMCA, the YWCA, and the Red Cross, often entertained American, Australian, and English forces with tea, food, games, and music. Their charity extended into the purchasing of additional properties that were converted into hospitals and officers' clubs. Through all of this, Mr. and Mrs. Sloane kept a tight relationship with many of the individuals who passed through their home and grounds. Hundreds of letters reveal the appreciation and gratitude felt by these men and women; many even came back years later to visit the place that held so many memories.

In the early 1920s, both William Jr. and E.K. attended Oxford University. The Sloanes, particularly Florence, took advantage of this time to travel throughout Europe, collecting objects from England, Spain, Italy, France, and Germany. These formidable years would provide the foundation of the Sloane Collection that is housed in the museum today.

The Sloanes never slowed making improvements to their home and estate. In 1922, physical construction began on the Gothic drawing room, designed by Philadelphia architect Frank Watson, and continued for three years. Also in 1922, a formal rose garden was begun on the east side of the property. At the time, it featured crushed bluestone paths, Italian marble seats, and stone vases and statues. During this period, the Sloanes altered their water tower by enclosing and expanding it to include a carpenter's studio and a sunken garden. This space was used by both Charles Woodsend and M.F. McCarthy as the staging ground for multiple expansions to the Hermitage.

The 1930s saw significant physical changes to the layout of the home. The dining room, Gothic drawing room, kitchen, and great hall were all physically moved to accommodate the addition of a south wing and a southwest second story between 1936 and 1938. It was also in this decade that the city of Norfolk saw the construction of the Norfolk Museum of Arts and Sciences. Mr. and Mrs. Sloane had been attached to the project from the mid-1920s and were the primary donors for the erection of the first wing of the museum. For Florence, this undertaking solidified her position as one of the most prominent spokespersons for the arts in Norfolk. Her philanthropic efforts were rewarded when she received Norfolk's Distinguished Service Medal; she was the first female to receive the honor.

Throughout all of the changes to the home and their lifestyle, the Sloanes continued to consciously add to their holdings of art and antiques. Florence spent the 1930s, 1940s, and early 1950s building her personal collection, as well as establishing the Norfolk Museums. With the assistance of dealers from across the United States and parts of Britain, she quietly amassed one of the most unique collections in the state. From 20th-century American painters to Coptic fragments, Florence Sloane had an eye for art that would place her among the more intellectual and thoughtful buyers in southern Virginia. The collection, and its place within the Arts and Crafts–style mansion, would become the catalyst for the creation of the Hermitage Museum.

In 1937, William and Florence established the Hermitage Foundation as a museum to encourage the development of arts and crafts and to promote the arts within the community. It was also meant to serve as a tool for understanding and promoting art as a living progressive influence in the lives of every individual. Such stimulation was meant to prove that the arts play a role in daily life. Ultimately, they contributed the house and its contents, the Hermitage gardens and grounds, and all other structures on the property to the foundation. The house was opened to the public as a museum on occasion in 1937, but closed temporarily in 1940 after the death of Mr. Sloane. The house was opened again to the public in 1942, with Florence Sloane remaining in residence upstairs until her death in 1953.

Since her death, the Hermitage has continued its mission to provide a place for the education of both the arts and sciences. The 12 manicured acres of grounds, the 42-room mansion, and a visual arts studio all continue to act as conduits for learning. As the philanthropic work of William and Florence comes into the public view, the museum hopes to demonstrate the stewardship the institution has taken on to protect and share the legacy of the Sloane family.

One

1895–1915

This west-facing view of the Hermitage shows the estate around 1912, following the additions of a butler's pantry, the dining room, and a mechanical building on the western side of the home. In its original conception, the structure was designed as only a five-room summer cottage. By this time, the home had already been made into the Sloanes' permanent residence.

Florence Adelia Knapp was born on February 20, 1873, the youngest of five children. Her parents, Jacob Frost Knapp and Deborah E. Knapp, were both native New Yorkers. William Sloane was born on November 1, 1868, to parents of Irish descent who had immigrated to the United States in the mid-1800s. He was the third of six children. Of the many accomplishments the two would make in their lives, none may be greater than their support for the arts. Florence and William were implants in Norfolk and had come to a city that was far different than the metropolis they had left. Their intentions were not to break down the barriers of centuries of differences, but rather to nurture an arts scene that for one reason or another never really took root in the south of Virginia. Knowing that there was a rich history surrounding the region, the Sloanes took it upon themselves to push for cultural change.

The Sloanes' first home was constructed with the assistance of English master wood-carver Charles Woodsend. It was located in South Norfolk on the corner of the Chesapeake Avenue and Ohio Street, which, at the time, was close to the knitting mills operated by the family.

William Sloane's uncles Foster Black lived across the street from them. The Sloanes' arrival in Norfolk begins with Black, the brother of William's mother, Margaret, who came to Norfolk in 1887. His intention upon arrival was to start a venture in knitting mills that would eventually become Foster Black & Company. William Sloane followed his uncle to Norfolk at the age of 19 and was made the superintendent.

Foster Black passed away in 1905, after which William Sloane acquired the existing Chesapeake & Elizabeth Knitting Mills in South Norfolk. William expanded the business further by obtaining the Tidewater Mills in Portsmouth and then changing the company's name to William Sloane & Co. In addition to owning multiple mills, William was heavily involved in the banking sector in Norfolk. He sat on the board of Norfolk National Bank for a series of years and was then president of the Peoples Bank & Trust Company. The Peoples Bank merged with the Savings Bank of Norfolk to become the Continental Trust Company, and William became the chairman of the new bank's board of directors. A final merging created the Seaboard National Bank of Norfolk, of which William was elected vice president.

As a child, Florence Knapp would walk from her home on Nineteenth Street in Greenwich Village, New York City, to her grade school. A resting point along this trip was the Metropolitan Museum of Art. It was here that Florence's interest in the arts began to grow. Throughout their early years in Norfolk, the Sloanes would make frequent trips back to New York to visit family and enjoy museums, galleries, and even the boardwalk, as seen here.

Florence is seen again here on a trip to New York City. The earliest photographs of the Sloane family come from trips to Long Island, New York City, and a cabin in the Adirondacks. Mrs. Sloane would continue to document her family's growth with the use of photography, which has allowed for an unparalleled insight into their lives.

In the early 1900s, the Sloanes kept an apartment in New York City, on Nineteenth Street near the National Arts Club and Gramercy Park. As most of their family still resided in New York, this home became a frequent rest stop for the family as they traveled the state.

A young William Jr. is seen here petting the much larger dog of a relative. This particular photograph shows a neighbor's house in South Norfolk. Most of the residences constructed near the Sloanes' home were designed and erected by Charles Woodsend.

In the early 1900s, Florence Sloane was not yet engaged in serious art collecting; instead, she was focused on establishing her home and family. William Jr. (left) was born in 1903, and Edwin, or E.K. for short, was born three years later, in 1906. The two boys are seen here around 1908.

The two boys pose for this photograph down a dirt pathway near the Sloanes' first home, in the Berkley section of South Norfolk. As the family began construction on the Hermitage, Mrs. Sloane noted that the very young E.K. was often found pushing grasshoppers through the floorboards of the unfinished structure.

In 1908, Charles Woodsend assisted with the construction of the Hermitage in its first phase as a five-room summer cottage. The plans he and Florence Sloane developed were constructed on the property they had purchased in the Tanners Creek district of Norfolk County in 1907. The Sloanes went on to buy additional lots in the Lochhaven neighborhood, which they later sold or gave to friends and acquaintances. These plans are the first that were drawn for the Sloanes, by Robert Pope and the American Boulevard Corporation in February 1908. At the time this plan was made, the Sloanes were only looking to purchase the property that the home sits on today. Additional lots in the neighborhood were bought a few years later and then sold in the 1930s and 1950s. Various records show the extent of land owned by the family being between 20 and 30 acres at the height of their buying of plots.

With expansions to the home taking place between 1910 and 1912, the Sloanes sought to further develop their property by constructing a gardener's cottage to house additional male staff. Designs for this structure were overseen by Charles Woodsend, and the building was completed before the end of 1912.

A horse and cow stable was erected on the north edge of the grounds, where the property meets the road. Blueprints show facilities in the stable for horses, cows, chickens, and a dormitory, along with many storage rooms and feed bins. This building also housed the family's motorcars from as early as 1909. Once the Sloanes had turned their home into a museum, they repurposed the building, making it a visual arts studio.

In November 1914, E.K. Bennett and W.J. Carter began work on a log cabin on the eastern portion of the property. By July 1915, the construction was complete, bringing the number of buildings on-site to four. This small cabin provided residency for numerous visiting artists throughout the subsequent decades. Bennett and his team of workers were active employees at the Hermitage for many of the early years. While often found making general repairs to facilities like the stable and the home, the crew also worked on solo projects on the estate. Bennett was responsible for the construction of the water tank tower in 1914 and the grass tennis court in 1915. The crew's largest contribution would be the alterations to the second floor of the home during the renovations in 1916.

In this view looking northeast over the foundation of a barrier wall, the tops of neighboring homes can be seen in the distance. Views like this were common on the property during the first few decades; as the years moved forward, the plants and trees around the property began to obstruct views like this one.

This view of the log cabin shows an earthen wall that was pushed up and supported by marsh grasses to protect the structure from the incoming tide. The small building stood several feet off the ground to allow water to pass under it should significant flooding occur.

The first of the seawalls built at the Hermitage was begun in October 1915. Throughout the following 40 years, numerous modifications were made to the existing structure. This image from the early 1930s shows a worker beginning to lay out the foundation of the wall near the log cabin.

Construction on the wall continued at the eastern edge of the property. The depressed land that is visible in this photograph has been absorbed by the river today. The low-lying marshes around the Hermitage have fluctuated in size since the land was purchased.

Piles of bricks are seen here as workers begin construction on what will become the east garden wall. Both the eastern seawall and the garden wall were built at the same time to ensure that the two would connect and act as a barrier against the river.

With the wall nearly complete, workers focused on making sure there was an adequate drainage system around the cabin so that water would not become stagnant around the site. This project was repeated several times while the cabin was on-site.

The first hall of the home took close to three years to complete in full. Additions like the dining room took Charles Woodsend another three years because lumber was rough-sawn and then planed by hand. The Hermitage, seen here around 1912, consists of the original five-room structure as well as, from left to right, the mechanical building, the kitchen, the butler's pantry, and the dining room.

What is now a heavily wooded area was once an open field for animals to graze. In this view looking west down the driveway, the top of the mechanical building can be seen over the snow-covered trees and path.

Charles Woodsend hailed from a family of woodworkers who brought him from Nottingham, England, to Canada in the 1870s. A decade later, he moved with his father, Thomas Woodsend, to the Berkley neighborhood of South Norfolk, where he eventually came in contact with William and Florence Sloane and forged a friendship that lasted until his death in 1927. Woodsend oversaw all construction on the Hermitage, even if he was not physically involved. In addition to erecting both of the Sloanes' homes, he is also credited with designing and constructing other buildings in the Norfolk area, including the Berkley People's Bank, additions to the Chesapeake & Berkley Knitting Mills, and numerous homes throughout Hampton Roads. His work was not limited to building homes and places of work; he also built furniture, some of which is still at the Hermitage. He is seen here with two hand-carved bed frames for the Sloane children.

The Sloane children were tutored at home. This decision was made largely because of the distance between the Hermitage and the closest school at the time, known as St. George's School, which was several miles away. The location of the Sloanes' home on Tanners Creek (now the Lafayette River) was still considered the country in the early 1900s.

Florence, William, E.K., and the governess (the boys' tutor) pose for a photograph on one of their outings. The Sloane children's education was not limited to lessons taught at home. Trips to plantations and historic homes throughout the state of Virginia were common. E.K. even went abroad as young as six years old.

William Jr. and E.K. pose with a friend in Tanners Creek, which is now the Lafayette River. At the time, the property was surrounded on two sides by open water, including a swimming hole that was marked off by a man-made rock formation. Many visitors to the site would allude to the beauty and serenity the Hermitage offered during their stay. A frequent guest was the painter Douglas Volk, who became a dear friend of the Sloane family. Following one of his visits, he wrote to Mrs. Sloane thanking her for her hospitality and included this pleasant view of the Hermitage: "My thoughts often turn towards Norfolk these days, and to my good friends in their Beautiful home by the sea. But the picture I form of the place does not contain any element of change which have come over the place since I saw it last. I imagine, however, that the beautiful aspect of things has not undergone any great transformation."

The Sloanes kept numerous pets at the Hermitage throughout their lifetime. Among the most commonly seen on the property were dogs. Here, a new litter of puppies entertains William Jr. and E.K. as a friend and a worker look on.

Mrs. Sloane often referred to her life in New York as providing an education on multiple levels. She even highlighted the Metropolitan Museum of Art as providing her with a free education. "I knew the objects in their galleries better than I knew the furniture in my own home," she wrote to a friend in 1934.

One of the first cars the Sloanes owned was this 1909 Packard Runabout Model 18. It is seen here with one of the hired drivers circling the original driveway. Cars were never a focal point of Mrs. Sloane's collecting, but she did try to sell this particular vehicle to various collectors as an illustration of the development of transportation.

E.K. and a hired driver pose next to the new family car in the mid-1910s. Few records remain regarding the hired driving staff. Those that do exist reference employees used in the 1940s and 1950s.

Family friends pose with Mrs. Sloane's most beloved dog, Zonoza. The bronze statues of her made by sculptor Harriet Frishmuth are a testament to the importance of this one particular pet to Florence. In a letter to Mrs. Sloane in 1927, Frishmuth mentions the casting of the bronzes she had sculpted and alludes to her excitement about how they will be received. "Your 'Dog' should be ready very soon now—Am expecting to get word from Mr. Drake any day now—Am anxious to see it in bronze." The dogs found around the Hermitage estate were more than just pets to the Sloanes. Letters between the Sloanes and friends often describe the well-being of the animals, and it was often a topic that received a full page of conversation. Zonoza's grave is located under a series of bushes outside of the alcove attached to the east wing of the home.

Two

1916–1930

The 1907 Jamestown Exposition was held a short distance up the road from the Lochhaven neighborhood in which the Sloanes built the Hermitage. At the time, only a few homes had been erected in this newly developed area of Norfolk. With the addition of a trolley system and better road access for the exposition, the neighborhood evolved into an affluent suburb just a few miles north of downtown.

The onset of World War I in 1914 saw the Sloanes' businesses increase in prosperity. Despite the fact that the United States had not entered the war yet, exports from the knitting mills made their way overseas in support of the war effort. Parties also began to take place on the property to show support for the militaries involved.

Florence and William Sloane stand with a military officer named Gibson Bishop and a man identified as "the Judge" in front of their home during a summer party in 1917. A letter from Bishop arrived later that year in which he writes, "We arrived in N.Z. on the 20th August after a nice voyage. I shall write later on when I have more time & give you details of our trip. Kindest Regards to you, Mr Sloan & the Judge. Does he still carry his gun?"

Before the Hermitage became a staging ground for events, Florence realized the need for a cultural center in southeastern Virginia. With the aid of Douglas Volk, Karl von Rydingsvard, and Bell Irvine, Florence organized the first meeting of the Norfolk Society of Arts at the Hermitage in 1916. They soon convinced the Irene Leache Memorial Association to join their movement and began using the association's well-furnished building on Mowbray Arch as their headquarters. Pictured are, from left to right, the Judge, Florence Sloane, and an unidentified friend of Sloane's.

A friend of the Sloane boys, Branch Jordan Jr. salutes the camera on the Sloane tennis court, which was added to the property in 1915. A similar sailor suit was worn by the Sloane children and would appear in a future painting by their family friend, portraitist Douglas Volk.

William Jr. (left) and E.K. (center) pose with Branch Jordan Jr. on their bicycles on the edge of the family tennis court. Local friends were hard to come by, and, given the distance to the closest schools, neighborhood boys were often tutored with the Sloane children.

Many events were held on the property, including this one involving the inflation of a dirigible. Gatherings on the property were common between 1912 and 1920, but, as time went on, the Sloanes became less focused on using their estate as a staging ground for entertainment.

Florence is seen here cruising on the family yacht *Caprice*. At the start of American involvement in World War I, the Sloanes donated their boat to the military to patrol the coastal waters of the eastern United States for German ships.

From another angle on the yacht, William Jr. is seen aboard (second from left), as well as members of the Navy who would go on to operate the boat during the war. A friend of William's sits closer to the camera, sheltering his eyes from the sunlight.

Close to 300 sailors and marines, along with five British sailors, were invited to the Sloane estate while on liberty to participate in various lawn games and festivities. The party was under the supervision of the Naval YMCA. Over the course of two years during World War I, the Hermitage saw over 1,800 servicemen visit the site for various events. From all of these military events came an outpouring of letters from various sailors who visited the estate during their stationing in Norfolk. They were often a simple thank-you, but some came with the hopes of starting a conversation while out at sea and on the front lines. From the records kept at the museum today, it is clear that Mr. and Mrs. Sloane did their best to return letters of support as frequently as they came in.

In addition to hosting military men at his home, William Sloane also purchased a residence in the neighborhood of Algonquin Park that he immediately gifted to the Fifth Naval District for use as a convalescent home for patients. The residence was encompassed by sizeable grounds and was only four miles from the naval base and Norfolk Country Club. The site was used by the government until November 1919, when it was returned to the Sloane family.

Friends of the Sloane family can be seen heading up the river on the yacht *Tycoon*. Just off to the left is the old trolley bridge that once spanned the Lafayette River.

Servicemen pose on the steps leading to the tennis court in 1917. Behind the line of trees is the old water tower the Sloanes used in the earliest years of the Hermitage's history. By the 1920s, the water tower was enclosed in a cedar-shingled structure that was also used as a wood carving studio for Charles Woodsend and his apprentices.

Games played on the lawn of the Hermitage included a "rooster fight," in which one contestant must pull another over a white mark, as well as a "tin cup" fight, a peculiar game that requires the participants to be supplied with a tin cup and a pillow. They must then each indicate their location by thumping on the cup, after which they go after one another with the pillows.

A Danish ship sails up the Elizabeth River in 1917. With Norfolk becoming a staging point for numerous naval fleets, the Sloanes and other prominent families in the region began to host gatherings and private parties for service members as America became more involved in the war.

Both William and Florence Sloane were involved with the YMCA and YWCA in the region. Mrs. Sloane helped run the post office for the military, which was housed in the YMCA, while William offered his services as a member of the board of the Navy's YMCA and equipped the gymnasium in the name of his sons. These facilities were occasionally transformed into dance halls for service members during World War I.

While on deployment, the six sailors assigned to the *Caprice* would send the Sloanes news of their voyages. Mrs. Sloane frequently sent them packages as well. Cases of ginger, sarsaparilla, and Coca-Cola were mailed to the sailors and even included notes from Florence, one of which reads, "I hear from the Skipper that the Boat has lost its whistle. I wonder if this will help them to find it again."

Florence Sloane (right) worked with the Red Cross as a women's work leader, where she oversaw knitting assignments. She is seen here on her tennis court around 1917 working on a knitting project with her sister Grace Stiles.

E.K. Sloane stands on the back lawn of the Hermitage, with the great hall visible in the background. The two puppies he holds overshadow the bits of detail that can be seen in the doors of the room behind him. When the home was later rotated to its current position, the visible white doors were taken and applied to the water tower.

Florence tends to a litter of puppies on the front of the property. The exact number of pets owned by the family is unknown, but there were always dogs present on the estate during William and Florence's lifetime.

The current location of the east garden was once a formal English rose garden with 25 beds. Each bed was planted with a different number of roses; some had four plants, some had nine, and some fifteen, but the setting was symmetrical. Mrs. Sloane drew this plan showing the exact number of roses in each bed. The beds featured 10 or 11 varieties of early hybrid tea roses from the 1910s and 1920s. If one totals the rose count found on the left border of this design, it reaches just over 600, which does not include some of the "old roses" or the sections that were "complete as is." The right column is a list of old roses that were to be moved to bed number 20, in the upper left corner of the plan.

A small sunken garden was added to the property near the water tower off of the main drive in the 1920s. The plan called for four rectangular beds to be surrounded by an outer wall of flowers that then focused inward towards a circular bed and a fountain.

With meticulous detail, Florence Sloane designed the geometric pattern of this formal garden, assigning hybrid tea rose varieties to fill the space in an elegant manner that would accentuate the color scheme.

Construction of the formal rose garden began in the 1920s. Over the course of the following decade, Mrs. Sloane added additional gardens around the eastern portion of the property. Her travels abroad then inspired a series of brick walls and pathways to be built in the same area.

Work on the east garden began in the early 1930s, with additions added throughout the decade. The view in this image looks out over the cove that connects with the Lafayette River, after the construction of the garden was complete.

Ivy seeps its way in and around a series of columns in the east garden. The millstones seen in the bottom of the image were collected over 10 years and blended in with the grounds in various formations throughout the 1930s and 1940s.

These stairs leading down to the swimming hole were put in around 1930. Just past the rocks of the jetty is the dock, which had earlier housed the *Caprice* but now held a small motorboat. Over the course of the following decades, this particular region was reabsorbed by the wetlands seen towards the center of the photograph.

Workers plant one of the trees that was meant to line a portion of the east garden. The gradual slope of the land was later evened out to create a walkway that would eventually incorporate the use of millstones in the path.

This image shows a wooden gateway guarded by two Chinese stone figures that leads in to the east garden. Various stone and bronze sculptures were placed around the property, with the majority of them focused in the manicured gardens on the eastern portion of the property.

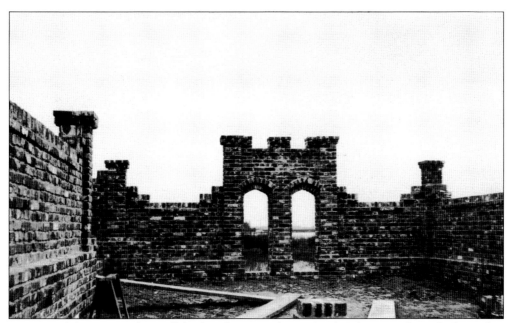

Portions of the east garden wall back right up to the wetlands. The view through the arches reveals a portion of the marshes, and, in the far distance, the old Lafayette River bridge. Today, the wetlands still border a majority of the east garden, but their expanse is far less than seen here in the 1930s.

While work was performed by W. and J. Sloane & Company on the bottom portion of the east wing, adjustments made to the living space on the second floor were undertaken by more familiar names. Beginning in August 1915, F.K. Bennett led a team of eight workers to perform alterations to the second story.

Over the course of 30 years, the Hermitage evolved from a five-room summer cottage into a 42-room mansion. The series of expansions that took place were performed by various architects, craftsman, and laborers. Between 1916 and 1918, the Hermitage underwent its largest addition. W. and J. Sloane & Company, out of New York City, was contracted to construct the east wing of the home. This expansion added five bathrooms, six major rooms downstairs, and seven rooms upstairs. W. and J. Sloane & Company only did the work on the first floor of the expansion. Preparation work was begun for this addition in 1915 and carried on through 1918 by local craftsmen, who made a series of alterations to the second floor to accommodate the incoming structure. An overlapping of detail work was undertaken by additional companies, some local and others from the Northeast.

This image shows one of the home's entrances to the right of the great hall. When the house underwent its transformation into a museum in 1937, the windows and stonework seen around and above the door were relocated to the south side of the home.

The original design of the Hermitage included this porte cochere that allowed guests to enter the home through the great hall. When this room was later rotated, the covering was removed with it. The driveway remained in a similar location that allowed vehicles to wrap around the front lawn.

This image, taken by Acme Photograph Co. of Norfolk, shows the Hermitage across the front lawn before the final renovations began in the late 1930s. This view shows the home at its longest, with the great hall still in its original position and the two-storied mechanical building attached via the kitchen. When the family decided to turn the house into the museum, nearly 80 feet of the home was removed to support additional gallery space that is now towards the center of the home. The orientation of the structure following the renovations created a boxlike shape on the western portion of the facility. Woodwork that had to be removed from the modifications was not discarded, but instead reintroduced to new segments of the home. The Sloanes did not want to neglect the craftsmanship that had been undertaken during the earlier phases of the home's existence.

This Hermitage floor plan, from after 1922 but before 1927, shows the finished east wing expansion, as well as the addition of the Gothic drawing room. Noted on the left side of the plan are the names and locations of rooms, which at the time reached a total of 28 on the first floor alone. This arrangement shows rooms 18, 19, and 20 still attached to the mechanical building, which contains rooms 21–24. When the home was rotated to its current position in 1937, rooms 18, 19, and 20 were pulled to the back of the home, where they were connected with room 16 and two new spaces not shown on this print. Floor plans of the home survive from nearly all of the expansions, including Charles Woodsend's original blueprints.

Beginning in September 1922, the Chapman Decorative Company of Philadelphia began the installation of the Gothic drawing room, also referred to as the music room, on the south side of the home. The primary architect for the room was Frank R. Watson, a well-known Gothic Revivalist who had been hired to redesign the interior of Christ and St. Luke's Church, on the Hague in Norfolk. The Sloane family attended the church, and they were inspired by it when beginning the initial designs for the room. The project was begun in plan form in 1921 by Charles Woodsend, and the final installations took place in 1923. The room only spent a little more than a decade facing the river before being shifted to the front of the home.

When first added to the home, the Gothic drawing room stood 10 feet in the clear and had walls 11 inches thick. The bricks that were exposed were referred to as "Arch" bricks and had been well burned to add color.

The 1930s saw the gardens around the property take on their own unique identity. It was clear early on that this was Florence's intention all along, but it took time for the plant life to match the character of the estate, which had undergone 30 years of work by this point.

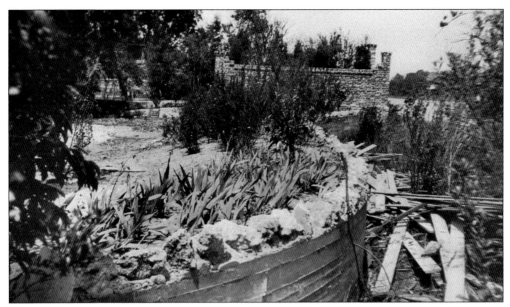

The eastern seawall is seen here undergoing another transformation in the 1930s. Various additions to this area, as well as additional bulkheads around the property, were added as agents of defense against the encroaching river.

William Sloane Jr. sits on an imported Italian bench on the edge of the rose garden with his back to the Lafayette River. With him are three German shepherds that belonged to the family. When this photograph was taken, renovations to the garden had not yet taken place. Instead of brick walls at the edge of the garden, a small patio along the river's edge met the marsh grasses.

Mrs. Sloane is seen here sloshing through the mud and playfully preparing to hurl a stone towards the camera. This photograph was taken near the construction of the eastern seawall, which is seen just behind her.

This aerial view of the home facing north shows the property in the late 1920s. The developing Lochhaven neighborhood can be seen to the north of the Sloanes' land. The Sloanes also assisted in erecting a yacht club towards the entrance of the neighborhood that is located just outside of the photograph on the right.

This photograph details the south shoreline on the property before any significant erosion had occurred. By the time this image was taken in the 1930s, a more durable seawall had been put up along the river. This structure made its way around the log cabin and ended at the wall of the east garden, which had been worked on extensively in 1930 and 1931. The rose garden is still visible slightly north of the cabin, and a new brick wall with iron fencing has been built to the west of the home. Visible in nearly all of the aerial photographs in this book are two additional green spaces that no longer exist. Following the driveway around the loop leads to the two open areas, on the left bordering the stable. The smaller space was once a vegetable garden, while the larger was a place for the cattle and horses to roam.

During the time that E.K. and William Jr. attended university, Florence kept an apartment in Oxford and traveled throughout Europe. Many museum purchases, for both the Hermitage and the Norfolk Museum of Arts and Sciences, were made during this time. Florence often shopped at the Army-Navy store in London. At the time, it specialized in outfitting families who were being sent to British colonies. It also sold goods brought back from foreign locations. It was here that she began to take significant interest in Eastern art. On one of her visits to an antiques store, she had the pleasant surprise of observing the queen of England browse through a number of dolls and porcelain. Florence's notes on the day demonstrate how elated she was that the queen had shown interest in an object that she had taken a liking to as well. Mrs. Sloane is seen here posing for a passport picture.

In 1923, E.K. was enrolled in Brasenose College of Oxford University, from which he graduated in 1927 and received a master's degree in 1929. He was on the rowing team while at school. In a letter to his mother, William Jr. describes his brother's skill: "He is rowing very well indeed, by the way, and if he continues to improve at his present rate, should with luck row in the first eight before going down."

William Jr. (third from left) was also on the rowing team at Oxford, before and during the same time as his brother. Because they attended different schools at the university, the brothers were occasionally in competition with one another.

While at Oxford University, both sons took the time to explore the continent as well. On a skiing trip in Davos, Switzerland, in 1928, E.K. noted in a letter to his mother that the poor conditions were affecting his time on the slopes. During this specific stop, he was only able to make three runs, all above 5,000 feet.

William Jr. is seen here sitting on a small stone wall in the countryside surrounding Oxford, England. Like his younger brother, Jr. often found himself traveling about Europe with friends. At one point, he even purchased a motorcycle to tour by road.

During her many trips abroad, Florence Sloane acquired thousands of objects of art for her home. These pieces became the foundation of the collection that is in the museum today. Her sons occasionally accompanied her on these journeys. In this photograph, taken in Italy in the early 1920s, E.K. stands on the far left and William Jr. is on the far right. Mrs. Sloane is turning her head in the direction of their guests. During this trip, they visited many secluded churches; picnicked at the top of Mount Etna, around the time of its eruption; met Arthur Byne, a Spanish furniture and artifact dealer and author; and purchased many Spanish artifacts now in the museum.

Mrs. Sloane took extensive notes while traveling abroad. While many of these journal entries focus on architecture and landscape, she occasionally pauses to reflect on nature itself, including in one letter about the eruption of Mount Etna, in which she writes, "Nature is so marvelous—and that lava shows clearly the cleansing of fire—it being burned clean itself . . . That old mountain proves that out of destruction, sweet clean things can grow."

In 1929, while in England, Mrs. Sloane carried her small beige notebook, which she called the artist notebook. She was fascinated with her visit to Allington Castle in June 1929. On three pages, she drew the setting of the edge, the distance, and the types of flowers between the edges, and describes the columns with roses growing in trellis. Four days later, she visited Sandringham and was inspired by the Gothic effect on a rubble wall, the same effect the 1920s brick wall had on the east garden at the Hermitage.

This retreating aerial view looking towards the east reveals the extent of the wetlands that once bordered the grounds. The bottom of the image shows the dense marsh that previously delineated the western portion of the property. At the time of the original purchase, there was very little foliage in that area. Aerial views from the 1920s show a limited amount of fringe vegetation along the river line that decreased the farther inland one went. The Sloanes' property was well shaded to begin with, except for the area closest to the road, which was used for livestock and horse grazing. Many of the homes seen on the edges of these aerial photographs were erected around the same time the first wing of the Hermitage was put up. The wetlands region at the bottom of this image was eventually dredged and is now a part of an active wetlands restoration program.

The Tudor-style main house, situated on the north shore of the Lafayette River, is an extensively decorated home that focuses on the use of natural oak and cypress. Sheep graze across the front lawn in this photograph, while millstones are seen piling up to the right of the house in preparation for their placement around the property. For Mrs. Sloane, there was an appreciation for things that were made by hand. In one lecture, she writes, "Handmade articles . . . have a sacredness beyond words to describe." She clearly felt that years of labor have a way of producing a type of beauty that stems from the efforts of the mason, the wood-carver, the architect, or the gardener.

From September through November 1927, Mrs. Sloane toured through Spain and France. During this time, she diligently recorded entries in her diary of visits to places such as the Pyrenees, Gerona, and Barcelona. While in Barcelona, she stayed at Montserrat. "Before leaving," she describes in her diary, "I made a very rough sketch of the courtyard paving in front of the church to copy in the carpenter courtyard at [the] Hermitage, should I ever have the time and material for same."

Mr. Sloane was a modest man who shunned publicity, but he never failed to respond to calls for service in aid of a worthy cause or foundation. His marked business ability led him to be a successful entrepreneur as well, which afforded him and his family the opportunity to cultivate an arts scene in Norfolk.

Three

1931–1940

Florence and William Sloane opened their home and grounds for the benefit of the Norfolk Museum of Arts and Sciences by holding a gymkhana in June 1932. A series of events took place on the property from 10:30 a.m. until the gates closed at midnight.

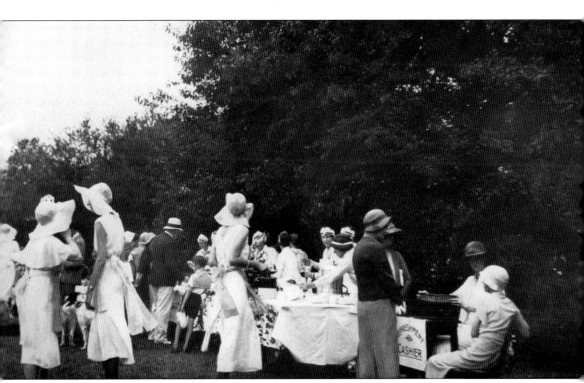

Activities at the gymkhana included a dog show, a flower show, pony rides, a firemen's band, fortune-telling, and a baseball game between ministers and lawyers. The price of a ticket entitled visitors to all of the events of the day, which culminated with a horse show ball that was highlighted by a moonlit dance as Johnny Benson's Orchestra played on the shores of Tanners Creek. Proceeds from the event went directly to the construction of the Norfolk Museum of Arts and Sciences building. While the Sloanes had been known to entertain on their property in the 1910s, they became more reserved about using the site in the 1930s and 1940s. Instead, they hosted events at the Norfolk Yacht Club, a short distance up the street from their home.

In the early 1930s, Florence Sloane began amassing a collection of millstones for use in the gardens. The majority of them came from Virginia, North Carolina, Pennsylvania, Maryland, and Georgia. Here, a mason erects a small wall on what would eventually become the millstone courtyard.

In the summer of 1925, during a visit to Wytham churchyard in England, Florence Sloane was taken with the architectural details of its exterior. In fact, she made a sketch of a unique door, which was later constructed and placed in the portico entrance to the east garden, as seen here.

65

Viewing the Wytham-inspired door from another angle reveals the level of craftsmanship. The door was carved by Swedish wood-carver Karl von Rydingsvard in the United States.

Two marble seats and two stone vases were purchased from A. Olivotti & Co. in Florence, Italy, for placement in the garden and the tennis court, as is noted on the bill of sale. Mrs. Sloane kept a limited number of objects in her gardens, especially after observing the layouts of other gardens while she was abroad.

Just as Mrs. Sloane provided meticulously detailed instructions for each room in her home, she played a great role in the development of her "outside rooms" as well. To express her ideas, she completed "fingerprints," or original drafts, of her ideal outdoor space. To this matron of the arts, the aesthetic fluidity of the home and garden together comprised one large piece.

Today, very little vegetation remains from Mrs. Sloane's time. Trees like these red cedars are original. Besides that, one heirloom rose, a few yuccas, and several crape myrtles are all that remain on the property that can be dated back to Mrs. Sloane's era.

These stairs leading down to the swimming hole showcase the use of water as a framing technique for the gardens. By pushing the boundaries of the gardens to the edge of the property, Mrs. Sloane was able to incorporate the beauty of the river into many views from her gardens.

Mrs. Sloane promoted and assisted in the organization of the Lochhaven Garden Club. She also gave the club a large silver loving cup, which became the Lochhaven Garden Club Trophy, to be awarded annually for outstanding horticultural achievement.

When the Sloanes first opened their property to the public, the hours of operation were rather limited. As Mrs. Sloane stated for a newspaper article, "The garden will be open every clear day between 2 and 5 in the afternoon, until the blossoms begin to fade." Dogwood, oak, pine, cedar, laurel, holly, and myrtle all grew on the site, providing a thick canopy over sections of the property. In between these forested areas were the open gardens, like the one seen here. After the Hermitage reopened to public in 1942 following William Sloane's death in 1940, regular hours were established. The museum retained some closure periods, like the month of July, but it was far more accessible than it had previously been. This allowed for an increase in traffic and the establishment of additional committees, like the Hermitage Auxiliary, to help provide academic entertainment.

Known as the east garden, this intricately designed landscape was constructed around 1930, upon Florence Sloane's return from her travels in Europe. During her time abroad, she kept a small notebook in which she recorded interesting architectural and landscape features that she planned to incorporate at her own home.

Visitors to the gardens and grounds paid a small admission fee to admire numerous acres of beautiful woodlands and wetlands, an impressive collection of millstones, and a formal garden with 25-year-old English boxwoods surrounding 25 varieties of hybrid tea roses.

Borrowing much inspiration from Spanish gardens, Mrs. Sloane incorporated such elements as high brick walls, which served both to separate the garden into sections and to encourage privacy. The progression of time has contributed to this experience, as the spaces are now well secluded.

Florence Sloane felt that there should be hesitation in separating the importance of a garden from the architecture that encompasses it. The two were inseparable in her mind, and, because of that, the walls and stairs of the Hermitage's gardens needed to demonstrate this unified relationship.

There was, in Mrs. Sloane's mind, a beauty to neglect. Though the gardens around the Hermitage were new and well kept during her lifetime, there was an obvious nod to the idea of letting age dictate the aesthetic of the gardens.

The east garden was to be an example of a series of outdoor rooms whose ceilings were the sky in the day and the stars at night. If the masonry did not delineate a space, then the hedges and trees were to act as natural dividers.

Elements of Italian and Dutch garden designs are present in the plans made by Mrs. Sloane. Areas around some flower beds are left devoid of any major shade from trees. Instead, these plots were to be open to the sun to promote quick growth for particular plants.

The use of high, arching windows in the brickwork is a common feature of the Spanish gardens Mrs. Sloane drew her inspiration from. Like those windows in foreign gardens, the pair seen here was built to open up to a pleasant vista, which in this case is the Lafayette River.

Various patterns were included in the design of the gardens to make walks more visually stimulating. This was not limited to the flower beds, as can be seen in the writhing woodwork in this doorway. Blending these arrangements with the different flowers and brickwork demonstrates the amalgamation of styles from which Mrs. Sloane drew influence.

Edward McCartan's *Girl with Shell* stands in the east garden in the early 1930s. When the home was renovated between 1936 and 1938, this statue was moved to a small grotto that sits on the south wall of the great hall.

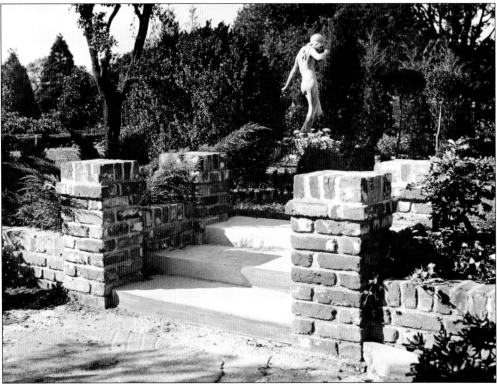

In addition to the formal gardens on the property, the Sloanes also had budgerigars from Australia. Several aviaries were located on the eastern portion of the property. The family eventually chose to no longer house the birds, and gardeners replaced the cages with flower beds.

With them having had birds on the property and been frequently visited by seafowl, it is not surprising that when the Sloanes established the Hermitage Foundation in 1937, they left open the possibility of the property serving as a bird sanctuary.

Incorporating ironwork in the various garden architecture on the property was an idea Mrs. Sloane seems to have gotten from Moorish gardens she found in Spain. She made a conscious effort to antique her structures, treating the buildings and walls around the estate with an aged effect to soften the outlines of the gardens. A series of lectures presented by Mrs. Sloane allude to the many inspirations she found for her own garden when traveling Europe and the United States. Noted consistently in these speeches is her particular liking for slender columns that are weighted by dense masonry on top. While the columns seen in this photograph do not personify the exact specifics set in her speeches, there are resemblances, and more examples can be found about the estate.

Cosmopolitan

BANQUET

In honor of

MRS. FLORENCE K. SLOANE

*For Distinguished Service as Norfolk's First Citizen
in Civic and Cultural Affairs for the year 1932*

——— AND ———

Installation of Officers

Norfolk Country Club
January 26, 1933
at 7:00 P. M.

On January 26, 1932, Florence Sloane received the Distinguished Service Medal from the Norfolk Cosmopolitan Club. At the time, she was the only woman to ever even be considered for the honor. Prior winners were associated with economic and industrial advancements in the region, whereas Mrs. Sloane had advocated cultural change. Her efforts would have a far greater and lasting benefit to the people of Norfolk than any who came before her. Upon accepting the award, she said, "The spending of large sums in the development of interest in the arts and sciences is an occurrence of more than aesthetic significance. We are living in a museum age and we must not be slow to recognize it."

Praise for Florence Sloane's award came from all parties present in Norfolk. In a letter to the selection committee expressing the qualities of Mrs. Sloane, these very potent words are written: "Aside from enriching the community spiritually and aesthetically, Florence's achievement had another far-reaching significance. At a time when material values were being stressed far out of proportion to their actual worth, she proclaimed through her accomplishments, in the arts and humanities, that those things which reflect the soul of a community must be reflected." Mrs. Sloane's part in the creation and organization of the Norfolk Museum of Arts and Sciences earned her the utmost respect from the city's patrons. The union between her and the Irene Leach Memorial Association also paved the way for the development of a conscious arts community in Norfolk.

Mrs. Sloane recognized that the Arts and Crafts movements in Britain and America had an incalculable value that could stabilize contemporary life in her time. The Hermitage was constructed with the purpose of acting upon those ideals. This photograph shows the interior of the great hall, which demonstrates the Arts and Crafts aesthetic in the 1930s.

The home has lent itself to promoting a better knowledge of all of the arts while encouraging their practical application and use, in both Florence Sloane's time and today. This photograph of the great hall focuses on the terra-cotta fireplace and the series of home furnishings that were carved to imitate antique styles.

The Hermitage is seen here in the 1930s, before the home was renovated for the final time. While Charles Woodsend had been the primary designer for the first phases of the home, his passing in 1927 established M.F. McCarthy as the chief architect to oversee the final transition of the building. McCarthy continued to work from Woodsend's woodshop, located in what had previously been the water tower.

The final reconstruction of the Hermitage, from 1936 to 1938, included the moving of the dining room, the addition of the central gallery hall and two upstairs galleries, and the movement of the kitchen, the mudroom, and the butler's pantry to their current positions on the back of the home. The Gothic drawing room was also moved at this time from the back of the house to the front.

Two of the Sloanes' dogs stand by as workers prepare to take apart a room. Despite the magnitude of the work performed on the home in the late 1930s, very little photography of the shift exists. Knowledge of how the rooms were relocated to their new positions remains in question, as there is uncertainty to how the physical movement took place—whether it was in segments or as entire units.

The east bay window located on the morning room was designed and built by Charles Woodsend. Below the window reads the quote, "Thies windows were made for Mrs. William Sloane in the yeare of oure Lorde MCMXVIII. Chas. J. Woodsend carpeder made this winovs by the grace of God." Additional woodwork was added to the window several decades later in an attempt to make the section look more ornate, but Woodsend's handiwork can still be seen. Woodsend also designed many of the iron fixtures found in the home and the gardens. A man known only as Mr. Moore made the iron pieces at the Chesapeake Mill, which William Sloane owned and operated. Moore's inspiration for his ironwork was from old Spanish pieces he had seen throughout his years.

This view of the home from the front lawn shows the Hermitage after the final stage of renovations. The central room seen in this photograph is the great hall, which was rotated 90 degrees. To the right of that room is the main entranceway. The Gothic drawing room can be seen behind the two large trees on the right.

One of the Sloanes' dogs sits on a radiator in what was once E.K.'s room. The view from the window overlooks the back lawn and the Lafayette River. Even though the Hermitage was opened to the public, rooms like this one were kept private for Sloane family members.

This photograph shows the house from the back after all of the 1930s modifications were done. The home's orientation was switched so that the doghouse, the mudroom, the butler's pantry, and the kitchen all were lined up and moved to the south lawn. The far left room in this image is the mudroom. The three windows to the right of that are to the dining room, followed by three more into the central hallway.

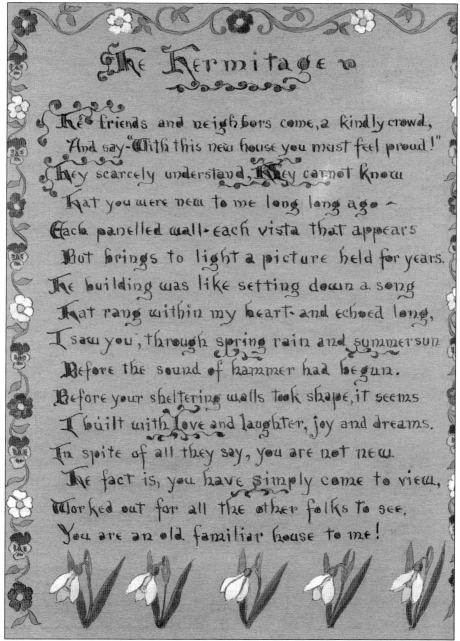

The Hermitage

The friends and neighbors come, a kindly crowd,
And say-"With this new house you must feel proud!"
They scarcely understand, they cannot know
That you were new to me long long ago –
Each panelled wall-each vista that appears
But brings to light a picture held for years.
The building was like setting down a song
That rang within my heart-and echoed long,
I saw you, through spring rain and summer sun
Before the sound of hammer had begun.
Before your sheltering walls took shape, it seems
I built with love and laughter, joy and dreams.
In spite of all they say, you are not new.
The fact is, you have simply come to view,
Worked out for all the other folks to see,
You are an old familiar house to me!

This poem, titled "The Hermitage," draws on the importance this retreat by the river had for the Sloane family. The home was begun in 1908 and remained the residence of Mr. and Mrs. Sloane throughout their lifetimes. Mrs. Sloane had spent most of her life collecting art, so, in her later years, she began converting her home into the museum it is today. She opened her doors and shared with the public a collection whose organization was defined by the idea that all good things of any age, period, country, or classification can be assembled into a harmonious whole. She emphasized this philosophy through the informal placement of her collection throughout the galleries and rooms of the Hermitage. It was a space she felt best suited for the education of adults and those who were serious about learning the arts.

The Sloanes felt there was a great need for a city such as Norfolk, tucked in the cradle of American history, to have an arts institution that reflected the importance of its location. Their efforts, and, more specifically, Florence's efforts, were not in vain. Speaking about the importance of such a museum, she said, "Museum work is one of expansion. It exists only to give and share with others—its ideals are lofty and far reaching, it aims to help by giving freely of intelligence, time, material, energy and finance. You will find this and only this among all Museum workers —paid or volunteer—a record hard to equal." In the same letter, her passion for the arts, and for providing a place for them to be seen, is laid out in this culminating lines: "For Museums are now living, active centers, where all classes, ages and both sexes come for help and productive recreation. They are a recognized and vital part of civic life and preserve for future generations documents of the historic past."

Around 1926, a ways and means committee, with Mrs. Sloane as chairman, was appointed for the purpose of erecting a museum. The city readily donated land in an area known at the time as Lee Park. Mrs. Sloane traveled throughout the country studying museums to create an appropriate plan for the Norfolk Museum of Arts and Sciences, seen here in the early stages of its construction in 1932.

Having found great interest in the designs of museums in the Midwest, Mrs. Sloane applied many of those layouts to her own. Florence also recognized the Fogg Museum in Boston and the Freer Gallery in Washington, DC, as providing some of the inspiration for her own project.

Another view of the foundation of the Norfolk Museum of Arts and Sciences shows some of the residential area that surrounded the plot of land. As is seen in this series of photographs, there is a significant amount of open space, which was eventually filled by the various expansions to the museum and an encroaching neighborhood.

Workers prepare to unload a large crate within the foundation. At one point during the construction phase, local prisoners were brought in to perform some of the manual labor. The men seen in this image are contracted workers, as most workers were during the majority of the project.

William Sloane was instrumental in promoting the Norfolk Museum of Arts and Sciences and was its president from its organization in 1926 until his death in 1940. The sign that stands on the left in this photograph lists the various donors who contributed to the funding of the museum.

Plans for a three-winged institution were in place, but funding the full structure proved to be difficult during the Depression era. Early on in the construction, it became apparent that there would not be an adequate revenue stream to support the erection of the full building. Because of this, teams of workers were brought in to hastily seal off the edges of the building.

Mrs. Sloane frequently visited the construction site to check on the progress of the building. She also took the time to photograph the various stages of the museum's development. These photographs were taken by her during a series of visits.

A federal works project furnished the maintenance workers to care for the Norfolk Museum of Arts and Sciences. With these workers and a secretary, funded by the Norfolk Society of Arts and interested friends, Mrs. Sloane was able to keep the facility operating.

Mrs. Sloane acted as the volunteer director for the Norfolk Museum of Arts and Sciences for 12 years. She left the position in 1945, having expanded the collection and reputation of the institution. With the general success of the museum's existence, the City of Norfolk began to contribute to its annual budget.

The light bills, water, and all other essentials were paid for in the first few months by proceeds collected from card parties held in the large gallery. Within the first year, the facility had proven its worth with attendance and support, even during the difficult years of the early 1930s.

On March 4, 1933, the first unit of the Norfolk Museum of Arts and Sciences was opened. As two-thirds of the foundation remained uncovered, Mrs. Sloane often referred to the erected building as the "lamb chop." Her plans for the building's additional wings were not realized in full until years later.

This aerial view shows the Norfolk Museum of Arts and Sciences on the open plot of land that was once Lee Park. The body of water that creeps towards the building on the bottom right is referred to as the Hague.

Four

1941–1953

The gardener's cottage at the Hermitage is seen here in 1947. This building remained a residence for groundskeepers and museum tenants for several decades. Today, it is used as a studio space for resident artists.

What was once the home of the family livestock was eventually converted into an art studio. Classes in drawing and painting were given twice a week, and instructions were based on "a conservative Modern technique that unites the traditional drawing and painting from the object with a modern study of planes, color scales, composition and arrangement." Children from ages 8 to 16 were admitted to Saturday morning classes, and adult classes were held on Wednesdays. There were outdoor landscape classes as well. Painting and sketching of the property was taught during the summer months to advanced artists, and additional courses in arts and crafts were offered throughout the year.

In August 1922, a bill from the Johnson Construction Company for supplies and labor performed on July 31, 1922, notes that work was performed on the "Shop" and "Tower House." By this time, the Sloanes had city water and were no longer in need of an exposed storage for water. Because of this, the water tower was enclosed for use as wood-carver's shop. At that time, it was in front of the boat docks. The most deeply involved wood-carver for the Sloanes was Englishman Charles Woodsend, who worked on the premises for over 20 years, hand-carving and installing the intricate interior paneling. This newly remodeled tower became his workplace for the last few years of his life, until he passed away in 1927. His ties to the family were important enough that he and his wife are buried alongside William and Florence Sloane.

In this view looking towards the wall of the east garden, what was once a formal rose garden is now the home for native plants found in the region. Many of the gardens around the property contain similar flora as was found during Mrs. Sloane's lifetime. With the passing of Mrs. Sloane in 1953, the property remained in the control of the Sloane family, with the assistance of an executive board. While the management of the collection and various activities kept the Hermitage in the social spotlight for decades following, there was some neglect to the grounds on a larger scale. The passing of time gave the property a look that may have suited Mrs. Sloane just fine, as the vegetation began to overtake the various brick structures throughout the area. An aged and rather rustic feel came over the Hermitage, making for a unique experience that even she could not have planned.

Florence Sloane's sister Grace Stiles (left) rests in a chair on the back terrace at the Hermitage. The small grotto she sits near backs up to the great hall and a set of French doors that leads into the central hallway. Edward McCartan's *Girl with Shell* can be seen in its new location after being moved from the east garden.

Florence and Grace (right) sit with Cary Weston Sloane, William Jr.'s wife, on the back terrace. Both of the sons took roles in assisting the museum after their father passed away in 1940. E.K. stayed on to manage the museum into the 1970s and continued to work with the institution well into the 1990s.

During World War II, the Hermitage and the Sloane family supported the war effort through diverse outlets. A unit of the Red Cross met at the foundation five days a week for two years, providing surgical dressings and performing sewing and knitting assignments. In addition, the galleries and grounds of the foundation were open to members of the armed forces at all times, free of charge. Several of the board members were also active duty military, including William Jr. and E.K., who served as a lieutenant commander. While the grounds were no longer alive with activities to entertain troops like they were during World War I, they remained a retreat from the stress of combat and travel for many servicemen and -women. Mrs. Sloane made many appearances and took many photographs with visitors to her grounds during these years. She also kept correspondences with those who had visited.

Grace (left) and Florence (right) stand with an unidentified friend during one of their many trips. By this time, Florence was often questioned by friends as to what inspired her to pursue the path she did. In a letter dated February 27, 1951, she writes the following to C.W. Grandy of the Norfolk Museum of Arts and Sciences after being informed that they would be dedicating a new set of wrought-iron sanctuary gates in her honor: "March 4th is a happy day to all of us, for it is the date that we first opened the museum eighteen years ago, 1933 . . . I wonder if the recent members realize how simply we began in those years. We had no furniture, no exhibition cases, no finished floors, no electrical fixtures, a temporary stairway, no assembly hall, and no funds . . . What fun we had in starting our 'Infant Metropolitan'! In order to finance our activities that first year, we had to have musicals, shows, exhibitions, card parties etc. Because of this, the first year we checked 40,000 visitors."

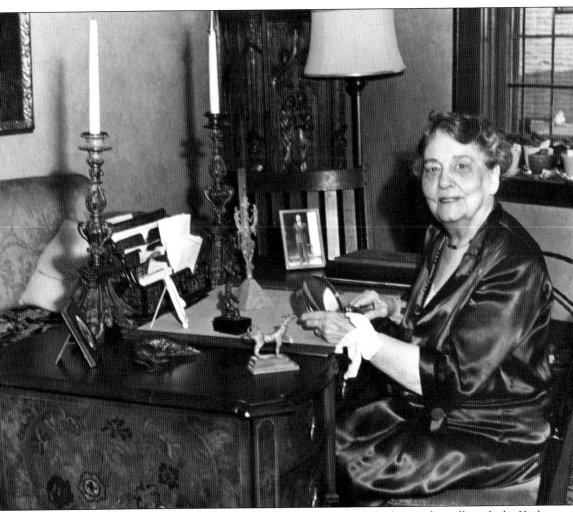

Florence Sloane sits at her desk, examining Luristan bronzes. Hand-carved candlesticks by Karl von Rydingsvard sit on her desk, along with a bronze cast of her beloved dog Zonoza by Harriet Frishmuth. This particular room was later converted into a contemporary gallery space for changing exhibitions. In the first half of the 1900s, the Sloanes entertained many noted artists at the Hermitage and avidly collected their work. Today, the home is filled with the artwork of many of these friends and contemporaries, including Douglas Volk, Helen M. Turner, Harriet W. Frishmuth, Anna Hyatt Huntington, Charles Hawthorne, Adolph Weinman, Hovsep Pushman, George Wharton Edwards, George de Forest Brush, Edwin McCarten, Stephen Reid, Frederick Waugh, Nicholas Fechin, Eugene Fichel, Edwin Howland Blashfield, Minna Citron, Sir Edwin James Poynter, George Gardner Symons, Peggy Summerville, and James Jacques Tissot.

Even during Mrs. Sloane's later years, she managed to stay active within the arts community. She frequently used her own studio space, which had previously been the stable and was used as a gallery for local artists and students who participated in weekly classes.

Mrs. Sloane stands with unidentified friends in a small gallery on the Hermitage property. As her health began to fail, she often relied on letters to communicate her thoughts and ideas on the state of both of the museums she had worked so hard to create.

THE HERMITAGE FOUNDATION MUSEUM

NORTH SHORE ROAD—LOCHHAVEN
NORFOLK 8, VIRGINIA

OPEN

Tuesdays through Saturdays.........1:00 - 5:00 P. M.
Sundays and Holidays................2:00 - 6:00 P. M.
— Admission 50 cents —

Free Thursdays10:00 - 12:00 A. M.
Closed Mondays

Admission to the Hermitage in the 1950s was 50¢, which allowed access to all the main galleries. Special exhibits, like the Oriental gallery, cost visitors an additional 50¢. This gallery held Japanese tsuba, Chinese potteries, Persian bronzes, embroideries, and ceramics, Coptic and Luristan bronzes and paintings, snuff bottles, ivories, and archaic Chinese vessels.

The Hermitage Foundation was begun in 1937. At the time, the Sloane family provided an endowment and covered all of the operating expenses for the institution. By December 30, 1937, the Sloanes had listed the mission of the foundation, ushering in a new age for the organization.

Management

The Board of Trustees which operates The Hermitage Foundation welcomes public interest, with the idea of widening the scope of its activities, and invites memberships and gifts. Museums are educational institutions, and are so recognized in the administration of Tax Laws. Gifts to this institution are deductible for income tax purposes.

Diagram showing location and routes to
The Hermitage Foundation Museum
7637 North Shore Road, Lochhaven, Norfolk 5, Va.

In a letter to Edgar Schenck, the director of the Honolulu Academy of Arts in 1947, Mrs. Sloane addresses the state of the Hermitage Museum, writing, " Our little collection has grown from that gathered originally for home uses and decoration, but now that our home has been largely converted to museum purposes, and considering the paucity of Oriental art in Virginia, we are emphasizing it here to make the Foundation perhaps more unique as an art center in this State."

HERMITAGE FOUNDATION, LOCHAVEN, NORFOLK, VIRGINIA
BURMA, 14TH CENTURY BRONZE, MAITREYA BODDHISATTVA

HERMITAGE FOUNDATION, LOCHAVEN, NORFOLK, VIRGINIA
NEPAL, INDIA, 17TH CENTURY BRONZE,
PADMAPANI BODDHISATTVA

A small community of international dealers of Asian art thrived in New York City. Selected objects were offered to the Sloanes by prominent dealers, including Ching Tsai Loo, Sadahiro Yamanaka, Dikran Kelekian, and Ton Ying & Co. Mrs. Sloane also often asked for advice from these dealers in regards to what types of Asian works she should acquire.

HERMITAGE FOUNDATION, LOCHAVEN, NORFOLK, VIRGINIA
SIVA, BRONZE, SOUTH INDIA 15TH CENTURY A.D.

Dealers approached the Sloanes by letter, sent them photographs and catalogues, and invited them to visit galleries or exhibitions. When the Sloanes showed interest in certain objects, antique firms often had them delivered to their home to allow an intimate connection to be made with the piece. After several months on display, Mrs. Sloane decided whether to keep the object or send it back and try something different. William and Florence K. Sloane amassed their collection over a 50-year period and assembled it in an informal manner throughout their 42-room home. Art pieces spanning 5,000 years harmoniously blend with the hand-carved oak, walnut, and teak interiors of the galleries. Among the thousands of objects in the Sloane Collection are a Neolithic jade *cong*, ancient Chinese ceremonial bronzes and *mingqi* (tomb figures), Indian Chola bronze statues, Spanish religious icons and furniture, European ceramics and paintings, hand-painted glass windows from Germany, and American paintings and sculptures. The Sloane Collection is a true celebration of the Arts and Crafts movement in America.

HERMITAGE FOUNDATION, LOCHAVEN, NORFOLK, VIRGINIA
VIEW OF MUSEUM BUILDING FROM LaFAYETTE RIVER

Postcards of the Hermitage from the 1950s provide an excellent window into the evolution of the building and grounds. Visitation records from this era show a steady stream of visitors from all over the eastern United States. Most of those who came, though, were from in-state and were often local.

HERMITAGE FOUNDATION, LOCHAVEN, NORFOLK, VIRGINIA
BRONZE FOUNTAIN, McCARTEN'S "GIRL WITH SHELL"

Views of the exterior of the home were common in publication, but what began to appear more frequently were images of the objects Mrs. Sloane had collected over the course of 50 years. Bronze sculptures like *Girl with Shell* and pieces by Harriet Frishmuth were commonly seen on postcards and in newspaper reviews.

The home of the Sloane family was opened to visitors, except for a few rooms that remained occupied by Mrs. Sloane until her death in 1953 and were then used by E.K. Sloane into the early 1970s. This view of the central hall leading towards what is now the main entrance shows off some of the collection, including two large Flemish tapestries and a sculpture by Adolph Alexander Weinman.

In this view looking down the central hall towards the great hall entrance, a large sixth-century marble Buddha can be seen seated on a lotus throne. The door to the left is the entrance to the Gothic drawing room, which features a carved lintel by Karl von Rydingsvard.

Visitors to the Hermitage during its early years as a museum were welcomed into a home with little boundaries. It was not a historic house that was static in its displays; rather, it was a home that was lived in and breathing. Everyday furniture was located beside one-of-a-kind objects from all over the world. Along with the informal placement of objects were the added touches of the wood-carvers who worked on the home. M.F. McCarthy inscribed several quotations into the lintels of the central house, including St. Thomas Aquinas's famous definition of art: "Art is simply the Right Method of doing Things . . . The Test of an Artist does not lie in the Will with which he goes to Work, but in the Excellence of the work which he produces." In a similar fashion, a more personal note was left on one of the lintels, reading simply, "This is the house that Jack built." Jack was the pen name Mrs. Sloane used for Mr. Sloane in the letters she sent while traveling.

A faint carving of a name can be seen above the door in the middle of this photograph. It reads, "Grace B. Stiles," Florence Sloane's sister. Beside the name, another carving reads, "Like her life sweet and strong, the organ breathes a song," a reference to the organ in the home, which was played by Grace during her stay with the family.

A pair of Continental Baroque–style tapestry-upholstered armchairs from the 17th century sit on either side of a 16th-century Flemish tapestry depicting women going about daily activities. Unlike these works, many of the furnishings found in the home were inspired by older styles from Europe but were actually handmade by craftsmen in the United States.

This photograph shows the alcove leading into the dining room. The painted image on the left was created by Scottish-born artist Stephen Reid. Named *The Master Craftsman*, the scene is actually the door to the dining room. Reid worked directly with Mrs. Sloane on the project, as it was meant to be a memorial piece for Charles Woodsend after his passing in 1927. Reid used a local carver and sculptor who had worked in numerous English cathedrals as the model. He was cast as the master craftsman who was meant to portray Woodsend. Surrounding the carver are four others who are meant to represent the Sloane family. Through the window and in the distance are the spires of Norwich Cathedral and the towers of Nottingham Castle. The painting was completed in 1927 and shipped to the Sloane home.

The Gothic drawing room was constructed by the Chapman Decorative Company in accordance with the plans and elevations provided by Charles Woodsend in 1921. Under the guidance of Gothic Revivalist architect Frank R. Watson and after a series of modifications to the design by him, the room was begun in 1922 and completed in 1923. Gustav Ketterer, a designer from Philadelphia, led a team that was on-site in Norfolk when construction began. He and Watson remained the primary contacts for the project throughout its duration. Following the installation, the Chapman Decorative Company, along with D'Ascenzo Studios, continued to make minor adjustments to window casings in the room through 1924. In this photograph, the rood screen, the limestone fireplace, the Moeller organ, and extensive boss work can be seen in detail.

The rood screen in the Gothic drawing room was carved by the Chapman Decorative Company and inspired by the architectural designs in the *Miraflores Altarpiece* by Rogier van der Weyden. The original screen, seen here, was destroyed by a fire in 2003. The current rood screen on display was carved by Agrell Architectural Carving.

Ironwork found in the Gothic drawing room was crafted by Philadelphia-based blacksmith Samuel Yellin. As in most of the home, the incorporation of leaded-glass windows was a must; however, this room does not have stained-glass inserts of European origin, which are common in some of the other rooms.

The great hall was the foundation of the original five-room summer cottage and, therefore, the base of the first model of the Hermitage. The room is seen here in the 1940s, set in its final position. It is the largest room in the main building and was once lined with a series of bookshelves, furniture, and art. The greater part of the furniture and decorative accessories now in the home were acquired between 1916 and 1929. Much of the Spanish furniture was purchased in the early-to-mid-1930s. During those years, the decorative arts were strongly influenced by Jacobean and Spanish designs, which were suitable for large country and suburban homes of the era. The drapery and upholstery textiles were rich and of heavy silks and velvets and leaned decidedly to the browns and blue-greens. The blues and greens are brightened by the reds and blues of the Oriental rugs and the blues and tans of the Asian carpets.

In a letter written by Florence Sloane to Florence L. Smith, dated April 4, 1943, Sloane thanks Smith for a gift of pieces of painted china and explains her thoughts on art in her home: "We are trying to show that all lovely things blend, of all ages and all kinds; and add to the charm of home living."

This detail of the south-facing fireplace shows off the handcrafted terra-cotta hearth and wood carvings done by Charles Woodsend. The set of chimney witches perched to the right and left of the fireplace were meant to ward off evil spirits that came down the chimney.

This 1947 photograph shows the primary entrance into the home. The two-storied space opens into the central hallways, which were added on in the late 1930s. In the upper left is the opening from which the organ pipes can be seen.

In this view looking towards the main door heading to the front lawn, one can see a hanging star lantern. This iron piece was given to Mrs. Sloane by a captain in the US military. The entranceway to the right leads into the great hall.

The formal dining room was originally added to the home between 1910 and 1912. The space was designed by Charles Woodsend and incorporated rough-hewn oak paneling lining the walls of the room. Furnishings by Karl von Rydingsvard were placed accordingly throughout the room. A contrast in styles can be seen between the geometric patterns presented by Woodsend and the Scandinavian Gothic styles present in Rydingsvard's pieces. The table, draped in lace, is actually a converted English floorboard that was modified by Woodsend. Though Woodsend oversaw a significant amount of the work performed on the home, the dining room remains a testament to the skill he brought to the Hermitage, as it was predominately crafted with his own hands.

There are numerous copies of paintings by the old masters in the house, but Mrs. Sloane was more interested in the artists, sculptors, and craftsmen of her own era. This is evidenced by her inclusion of works by artists like Frederick Waugh, Charles Hawthorne, Douglas Volk, Helen Turner, Harriet Frishmuth, and others who were active in the 1920s and 1930s.

This photograph of the Sloanes' master bedroom shows the oak veneer that encompasses the entire space. Teakwood planks were hand-tooled into the floor at irregular widths and then dovetailed, keyed, and pegged with walnut pegs. The bed frame is an American early classical, carved-mahogany four-poster bed.

The morning room and its attached alcove follow the general theme of the east wing expansion and are made from quartered American white oak. All of the carvings found in the room are based on models taken from the antique, and the linen-fold carving is cut from the solid wood, not glued on. The fireplace consists of a buffed limestone mantle and a marble hearth with ironwork by E.F. Caldwell. The ornamental ceiling is painted and glazed in an old ivory color, while the windows are set with imported English crystal glass fitted into metal frames that open inward. This particular photograph shows the room in the late 1940s, with a portrait of Florence Sloane painted by artist Ernest Ipsen in the center.

Mrs. Sloane's dressing room is made of harewood, and, when it was first installed, contained a built-in dressing table and wardrobe. The window sash is made of gulf cypress and was later painted over. A teak floor with a unique herringbone pattern is laid in narrow strips that are scaled to the room's dimensions. Compared to the other rooms in the home, this particular space provides a stark contrast from the English Tudor theme found elsewhere. The coiling light fixtures were made by E.F. Caldwell, as were many of the mounted lights of the 1916 expansion. Both Mr. and Mrs. Sloane had their own private baths and dressing rooms on the first floor. Each was outfitted with unique fixtures and amenities. Mr. Sloane's bathroom later had an elevator installed in it to make the second floor easier to access for Mrs. Sloane in her later years.

The Sloanes established the Hermitage Foundation as a nonprofit corporation in 1937. Mrs. Sloane went on to say that one of the museum's main purposes was to support "the greater understanding of European and Oriental nations through their arts and crafts, with special stress upon those less known ritualistic arts of the Far East." While the Sloanes purchased their Asian art through prominent dealers in New York and abroad, they would often call upon experts in the field to assist them with their acquisitions. From the mid-1940s until Mrs. Sloane's death in 1953, A.G. Wenley was Mrs. Sloane's primary contact on all matters Asian. At the time, Wenley was the director of the Freer Gallery in Washington, DC, where he would keep regular correspondence with Florence through phone conversations and letters. Some of the Sloane Collection's most prominent Asian antiquities were guided to her by Wenley.

This upstairs gallery was home to a large majority of the Asian collection when the museum was opened. Florence's understanding of Asian art came through several decades of personal research and the guidance of several prominent dealers and collectors. The first piece added to the collection was a Japanese bowl that was gifted to Mrs. Sloane from her sister. Despite the fact that Asian artwork would not become Mrs. Sloane's focal point until the 1930s, it is worth noting that she was purchasing objects from China, Japan, and India as early as 1901. While she strived to incorporate art into her home as one living entity, she did tend to itemize the Asian pieces in groups to better show the their cultural significance.

This hallway led to the two Sloane sons' childhood bedrooms. The center of the hallway once featured a carved rood screen made by Karl von Rydingsvard. The remnants of the screen can be seen in the circular patterns found on the right side of the image. William Jr.'s bedroom was on the left and E.K.'s was on the right. The layout of the upstairs mimics, in a smaller proportion, the layout of the first floor. The two sons had access to the ground floor via a hidden set of stairs, but, often, they found solace in their own living quarters, which included a sleeping porch and personal bathrooms.

Once the house was opened to the public, this small but well-selected library of standard works on art, history, and cultures was made available to students. There was also a designated reading room that could be reserved for individuals or larger groups, depending on the purpose of the visit.

Despite the size of the home, the Sloanes' kitchen is relatively small in comparison. When joined with the butler's pantry and an adjacent mudroom, however, the space seems much larger. Unlike the majority of rooms in the house, the kitchen was not meant to be seen by the general public.

A total of 16 of the 42 rooms in the house were wired up to this butler's pantry so that the Sloanes could call on service when needed. The room is seen here in 1947, after it had undergone several transitions in size and look since first being added to the home after 1910.

This shingled room is the sleeping porch on the second floor. In its early years, this room was screened in to allow the cool air off of the river to act as air-conditioning for the two Sloane sons who used it. These two hand-carved bed frames were made by Charles Woodsend.

Mrs. Sloane felt that religion used the universal language of art as a means to explain different cultures. Her respect for all religions was made apparent by the acquisitions she made over the course of 50 years. She began purchasing Islamic wares in the 1940s and early 1950s to complement her growing Asian collection.

This is one of the private rooms Mrs. Sloane kept after opening the house to the public. Family photographs sit on the table to the right and pieces of contemporary furniture are placed around a window that looks out over the millstone courtyard.

For an additional 25¢, visitors could walk into the Sloane family vault and view their silver collection. Custom wares by Tiffany & Co. made for the Sloanes following their marriage and move to Norfolk were on display. This case also occasionally housed some of the more valuable Russian pieces, including icons and *oklads*. A portion of the Russian collection was once the property of Alexander III and came to the Hermitage through sales in London. The vault was an addition that was put on in the 1930s. In preparation for visitors coming into their home, the Sloanes had this space modified from its original position, which was accessible through a hidden paneled door. This entryway can be seen in the central alcove, blending into the woodwork near the dining room entrance.

This view from the back lawn facing south shows the edge of the property as it drops off into the Lafayette River. The land around the Hermitage was long thought to be an undesirable place to live. By the early 1900s, however, the perception of the swamps and fields of north Norfolk had begun to change. The city saw a chance to expand both economically and socially, and, since then, there has been no looking back. The Lochhaven neighborhood grew and filled with homes as stunning as the Hermitage, the military established itself a few miles up the road, and ports rose from the marshes to usher in a new level of prosperity to the region. All of this can be seen daily on the property today. It is what makes the Hermitage's 12 acres a reminder of what once was and what the future can hold.

Where the east wing ends is where the magnolia tree grows. When it was planted, it was no taller than an average person, barely making its presence known on the grounds. As the years have gone on, the tree's presence has come to personify the Hermitage's own growth. Its company is undeniable, and yet it blends itself so well into its surroundings. The glossy leaves and fragrant white blossoms provide as much charm as the cedar-shingled home it shares space with. Today, it acts as a cover from the rain, a setting for a photograph, and a quiet place to reflect. Of course, there is more to be said about every plank of wood and flower in bloom at the Hermitage, but, for now, we will rest in the shade of all that has been accomplished.

DISCOVER THOUSANDS OF LOCAL HISTORY BOOKS FEATURING MILLIONS OF VINTAGE IMAGES

Arcadia Publishing, the leading local history publisher in the United States, is committed to making history accessible and meaningful through publishing books that celebrate and preserve the heritage of America's people and places.

Find more books like this at
www.arcadiapublishing.com

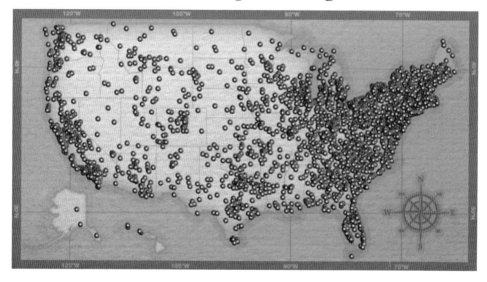

Search for your hometown history, your old stomping grounds, and even your favorite sports team.

Consistent with our mission to preserve history on a local level, this book was printed in South Carolina on American-made paper and manufactured entirely in the United States. Products carrying the accredited Forest Stewardship Council (FSC) label are printed on 100 percent FSC-certified paper.

MADE IN THE USA